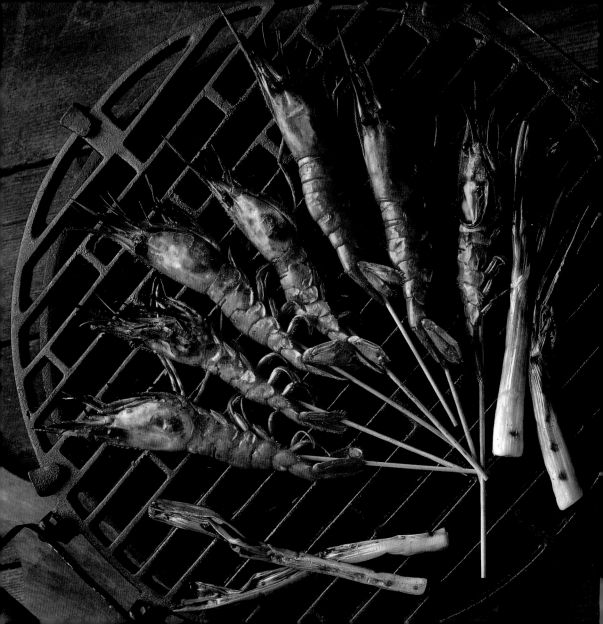

THE ASIAN GRILL

BY David Barich & Thomas Ingalls

PHOTOGRAPHY BY Dennis Bettencourt

FOOD STYLING BY Érez

SMITHMARK

This edition published in 1998 by SMITHMARK Publishers
a division of U.S. Media Holdings, Inc.
115 West 18th Street
New York, NY 10011

SMITHMARK books are available for bulk purchase for sales promotion and premium use.
For details write or call the manager of special sales:
SMITHMARK Publishers
115 West 18th Street
New York, NY 10011
(212) 519-1300

The Asian Grill was produced by
David Barich & Associates
870 Market Street, Suite 690
San Francisco, CA 94102
(415) 288-4525
Email dbarich@barichbooks.com

Printed and bound in Singapore

Library of Congress Catalog Card Number: 97-62209

ISBN 0-7651-9075-3

Produced by David Barich

Jacket Cover Design: Melanie Random
Interior Book Design: Ingalls + Associates
Designers: Tom Ingalls, Tracy Dean, and Margot Scaccabarrozzi
Photography by Dennis Bettencourt
Photographer's Assistant: Jean Lannen
Food and Prop Styling by Érez

The epigraph is reprinted from *Haiku, Volume 3: Summer–Autumn,* by R.H. Blyth,
with permission of Hokuseido Press.

The sandy shore;
Why are they making a fire
Under the summer moon?

— Shiki, translated by R.H. Blyth

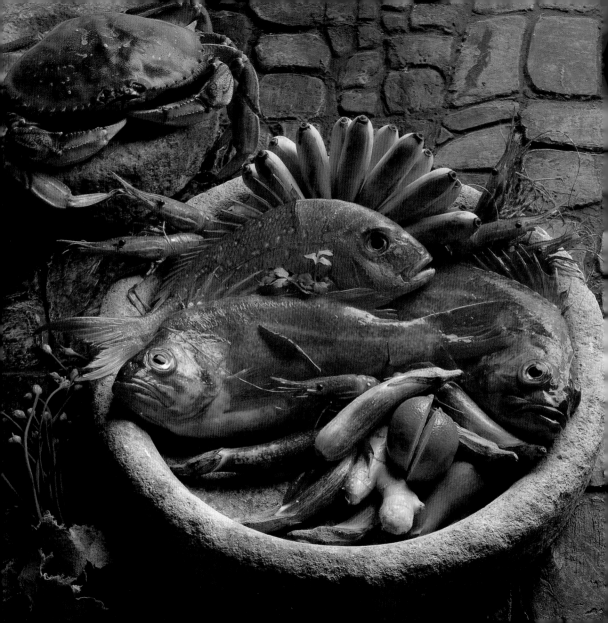

CONTENTS

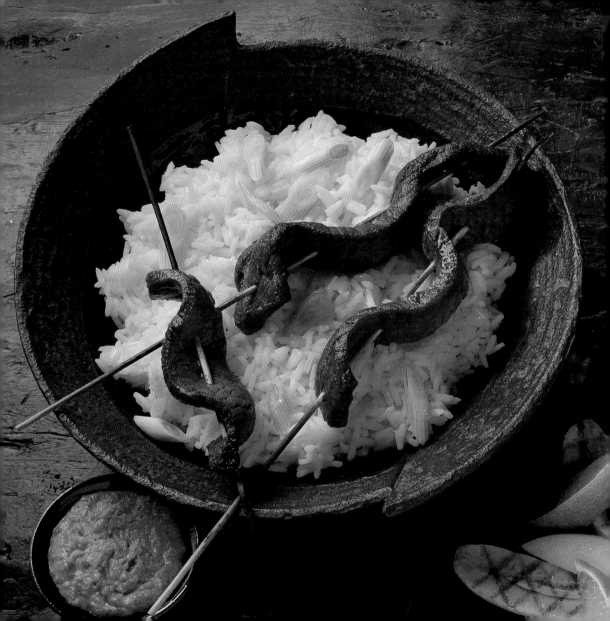

INTRODUCTION

The fragrance of burning charcoal has floated in the air of Asia for centuries. Until recently, charcoal was the most common heating fuel in homes throughout the continent and in Japan, and charcoal heaters may still be found in some rural locations. In *Snow Country,* an evocative novel written in 1956 by the Nobel Prize–winning Japanese author Yasunari Kawabata, the *kotatsu* is mentioned several times as the only heat source for the inns and homes of the cold Japanese Alps, where the story takes place. This simple device was a small charcoal brazier with a wooden frame built over it; a quilt draped over the frame held in the heat.

Long favored as a fuel because it is lighter in weight and thus easier to transport than wood, charcoal is used today for cooking in small grills in the home, on the street, and in many Asian restaurants, where grills may be set in the center of the table so that guests can cook their own food. Such table grills are commonly found in Korean restaurants. In Japanese robatas, the customers sit at a counter surrounding a large grill, where the chefs cook food to order. Yakitori restaurants and street vendors (along with noodle shops) are the Japanese equivalents of American fast-food purveyors, and the nearest source for these grilled skewers of meat, chicken, fish, and vegetables may be found in any Japanese city or town by following the mingled smells of charcoal smoke and grilling food.

The Koreans have an extensive history of grilling meats over charcoal, particularly beef; in this meat-based cuisine almost every part of the animal may be marinated, grilled, and served with the incendiary chili-pickled vegetables known as kimchi. Grilled meats were introduced to the general Chinese populace in the seventeenth century, when the nomadic

Mongols brought their tradition of grilling beef and lamb to Peking. Several classic Chinese dishes, such as barbecued pork and grilled squabs, are still cooked over charcoal, but the tradition of grilled street foods eaten as snacks is much stronger in Japan and Southeast Asia than in China. Outdoor grilling is ubiquitous in the tropical climates of Thailand, Vietnam, and Indonesia, where food wagons and food vendor stalls offer a wide variety of satays, sates (the Indonesian spelling), and kabobs, marinated foods grilled on bamboo skewers and served with pungent dipping sauces made with fish sauce and sometimes ground peanuts.

Asian grills entered American culture in the form of the hibachi, the portable Japanese cast-iron grill that was found on back porches and at picnics throughout the United States in the fifties and sixties. Now small portable kettle grills, which are lighter in weight, are more popular, but the hibachi is still in use. At the other end of the grill spectrum is the kamado, the Japanese ceramic grill-oven that many grill chefs consider to be the ultimate grill. Although it is heavy and expensive, it comes in different sizes and has an optional wheeled base; it also has the advantage of cooking hotter and holding heat longer than any other kind of grill, much like the great clay tandoor ovens of India (see Mail-Order Sources, page 68, for a source for kamados). The kamado is particularly suited for cooking large pieces of food that need long, slow cooking, but you don't really need one for any of the dishes in this book. All recipes for *The Asian Grill* were tested on a basic American kettle grill, with the cooking rack fixed 6 inches above the fuel grate.

You will not need any special cooking tools for preparing the dishes in this book, but you may want to add some pieces of Asian cookware to your kitchen if you don't already have them. A Chinese cleaver is a good all-purpose tool with many uses in the kitchen, from flattening sliced meats and chicken breasts to cutting through pieces of meat, chicken, and fish that are too large for a French chef's knife. Bamboo skewers are best for grilling satays and yakitori; these sharpened pieces of bamboo wood come in cocktail and entree lengths. To keep the exposed

portions of bamboo skewers from burning on the grill, they should be soaked in water to cover for 30 minutes to 1 hour before using. Wooden Japanese chopsticks and the larger plastic or wooden Chinese chopsticks have a multiplicity of uses at the grill and in the kitchen, including moving hot foods and stirring ingredients. Other good basic Asian cooking tools include a stove-top wok (for gas stoves), a set of bamboo steaming baskets, and a variety of small dishes and bowls to hold dipping sauces and condiments.

The Asian Grill brings you a selection of classic grilled foods from China, Japan, Korea, Vietnam, Indonesia, and Thailand. Two traditional side dishes accompany each grilled entree. Some dishes that are considered snack foods in Asia have been translated into American cooking as main courses. Many of the dishes and ingredients in this book have long been assimilated into American cuisine and culture, and most of us are used to eating Asian foods in restaurants. If you have never cooked Asian food, however, this book is a good introduction to it, as most of the dishes included here are simple and

quick to make, and all of them use foods that are widely available in supermarkets and Asian groceries. You may find yourself combining side dishes with other main courses, or coming up with your own versions of marinades and sauces from the basic Asian pantry described in the "Asian Ingredients" section. Even if you are something of an expert at cooking Asian foods, you will find this book a useful source for grilled dishes, and "Basic Grilling," beginning on page 21, is a summary of everything both beginning and experienced grill chefs need to know in order to grill creatively and well.

Whatever your experience in cooking Asian foods, *The Asian Grill* will help you to expand and refine your repertoire of grilled dishes. We hope that this book will make grilling more fun for you by introducing you to new dishes and flavors from the long tradition of charcoal cooking in Asia.

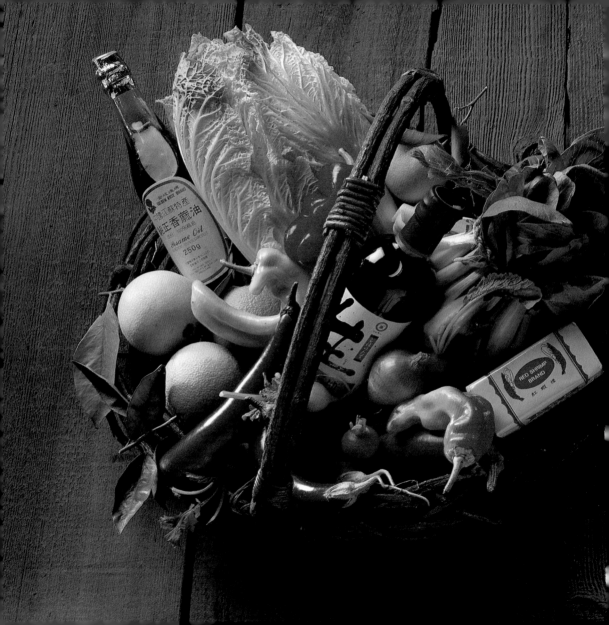

INGREDIENTS & TECHNIQUES

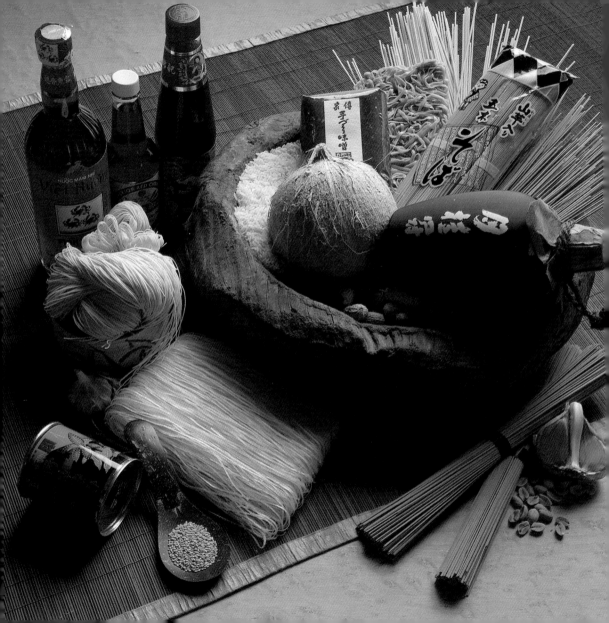

ASIAN INGREDIENTS

The following ingredients are available in many supermarkets as well as in Asian markets.

Asian sesame oil: Also known as **toasted sesame oil,** this dark brown, intensely flavored oil is made from toasted sesame seeds.

Black bean sauce, fermented black beans: The sauce, available in jars, usually has garlic added to it and is a strong, pungent addition to stir-fries and marinades for grilled foods. The beans, also called **salted black beans** or **preserved beans,** are available in plastic bags. They should be crushed and mixed with garlic and a liquid such as Chinese rice wine.

Bok choy: Also known as **Chinese white cabbage,** this vegetable has sturdy green leaves and a crisp, swollen white base. It is available full size or as **baby bok choy.**

Chinese broccoli: Like Italian broccoli di rape, Chinese broccoli has elongated stems, small flowers, and large floppy leaves. Regular broccoli may be substituted.

Chinese cabbage: Also known as **celery cabbage.** There are several varieties of this vegetable, including **napa cabbage,** but most of them are large and have crinkled, curly leaves with wide ribs that resemble celery.

Chinese rice wine: Also called **Shaoxing wine,** this rice wine resembles dry sherry, which may be substituted for it.

Chilies, hot red or green: The most common fresh chili used in Southeast Asia is the very small, narrow green or red **Thai,** or **"bird," chili.** It is hotter than the red or green **jalapeño** or **serrano chili,** either of which may be substituted for it. Store green chilies wrapped in a

paper towel in a plastic bag in the refrigerator; store red chilies at room temperature, where they will eventually dry for later use. Use rubber gloves when handling chilies and be careful not to touch your eyes or mouth; wash the gloves, knife, and cutting board in hot, soapy water.

Chili oil: A pale red oil flavored with dried chili. Only a drop or two of this flavoring will add heat to a dish.

Cilantro: The green leaves of the coriander plant, also called **fresh coriander** or **Chinese parsley,** add a distinctive taste to other foods. To store, place the trimmed stem ends in a glass of water, cover the leaves with a plastic bag, and refrigerate.

Coconut milk: Unsweetened coconut milk, made from steeping grated coconut in water, is available canned or frozen in Asian and Indian markets.

Dashi: Also called **sea stock,** this mixture of dried seaweed (kelp) and dried fish (bonito) is the basic Japanese stock. Use instant or bottled dashi as a soup base or as a basic ingredient in marinades and sauces.

Fish sauce: A pungent liquid made from brined, fermented fish. Fish sauce is used extensively in Southeast Asian marinades and dipping sauces, usually mixed with a little sugar and a fresh ingredient such as carrot, ginger, green onion, or cilantro.

Five-spice powder: A mixture of cinnamon, cloves, Sichuan peppercorns, star anise, and licorice root, this powder adds a musky-spicy taste to dry rubs and marinades for grilled foods.

Ginger: The rhizome, or underground stem, of the ginger plant is available fresh in "hands" in most markets. Choose firm, heavy hands and refrigerate wrapped in a paper towel inside plastic.

Hoisin sauce: Made from a paste of fermented soybeans, hoisin sauce is flavored with five-spice powder, dried chili, and other ingredients. It is good in marinades and sauces for grilled foods.

Lemongrass: This subtly lemon-flavored woody stalk is available in dried shredded form, but it is being grown more and more in this country and is sometimes available fresh. Use only the base of the stalk. Lemon zest may be substituted.

Mirin: Also known as **sweet sake,** mirin is a common ingredient in salad dressings, marinades, and teriyaki. The sugar in mirin helps give a glaze to grilled foods. Dry sherry with sugar added to taste may be used as a substitute.

Miso paste: A paste of fermented soybeans, miso comes in a variety of colors, flavors, and textures. **Red miso** is an all-purpose sauce that may be diluted to eat as soup, added to other sauces, and used as a glaze for grilled meats.

Noodles: The wide variety of Asian noodles includes **bean thread noodles,** made from mung bean starch and also called **transparent noodles, cellophane noodles, vermicelli,** and **mung bean flour noodles.** These very thin dried noodles must be soaked in warm water before being stir-fried, deep-fried, or used in soup or as a bed for other foods. **Rice stick noodles** are also called **dried rice flour noodles** or **rice vermicelli.** Sold as flat dried sticks in various widths, they are usually soaked in warm water before being used in the same ways as bean thread noodles. **Chinese egg noodles,** also

called **wheat flour noodles** or **mein,** are available either fresh or dried. Japanese noodles include brownish-gray **soba noodles,** which are made from buckwheat and wheat flour and sold either fresh or dried, and **somen noodles,** thin wheat-flour noodles sold dried and usually eaten cold.

Noodle soup base: A dried or concentrated-liquid soup broth made of soy, bonito extract, and dashi.

Oyster sauce: Made from oysters, water, and cornstarch, with a little caramel coloring, oyster sauce adds flavor to any number of stir-fries and noodle dishes.

Rice: Long-grain, or **Indian, rice,** is most commonly eaten in China and Southeast Asia. **Short-grain,** or **pearl, rice,** which is generally preferred in Japan, is shaped like small fat ovals and is stickier than long-grain rice. **Sticky rice,** also called **glutinous rice** or **sweet rice,** is stickier yet and is often rolled into balls with other foods or served in sweet cakes. **Jasmine rice** is a long-grain rice popular in Thailand for its sweet, jasminelike fragrance.

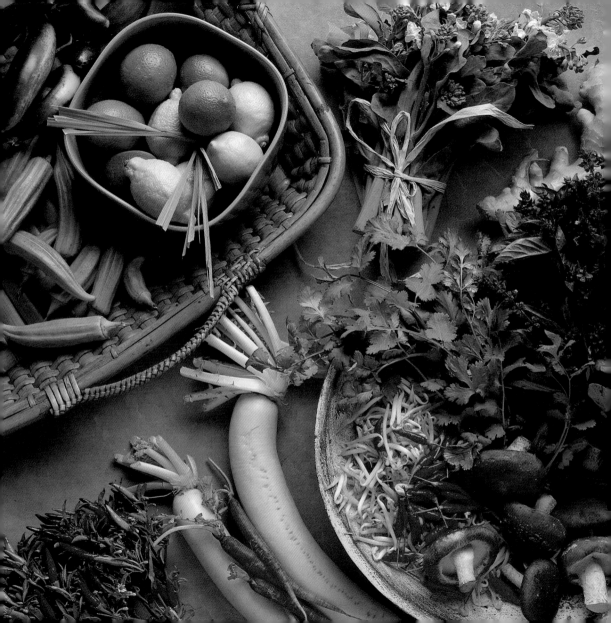

Rice paper: Translucent, tissue-thin sheets of noodle dough made from rice flour and water, rice paper is sold in 1-pound packages. Brush dried rice papers on both sides with water or soften them between two damp kitchen towels before using. Fresh rice papers may be found in some Vietnamese markets.

Rice wine vinegar: Unflavored rice wine vinegar gives zest and interest to sauces, marinades, and salad dressings. Distilled white vinegar, though stronger in taste, may be substituted.

Sake: Japanese rice wine, clear and slightly sweet, is used in marinades and sauces; dry sherry may substituted.

Shrimp sauce: This strong, pungent sauce is made from dried shrimp and salt; only a small amount will add depth to a sauce or marinade.

Soy sauce: The Chinese use two kinds of soy sauce, **light** or **dark,** depending on the color and delicacy of the dish. Use dark soy sauce for robust dishes in which you want a deep color, such as marinades for grilled beef or pork. **Japanese soy sauce** is fairly light and may be substituted for light Chinese soy sauce. **Tamari** is a dark, nonwheat Japanese soy sauce that may be used in place of dark Chinese soy sauce.

Tofu: The Japanese name for **soybean curd** or **bean curd,** which is made from coagulated curds of soybean milk. Choose the firm variety for grilling and stir-frying, the soft variety for soups. The firm variety is best when drained before using; see the recipe on page 50. Store tofu in the refrigerator, immersed in fresh water and covered. Change the water each day and use the tofu within 2 or 3 days of purchase.

Wasabi: A fiery green condiment made from the wasabi root and available either powdered or in paste form in a tube. It is mixed to taste with another ingredient, usually soy sauce, for use as a dipping sauce.

BASIC GRILLING

The following pointers are the keys to successful grilling.

1. Keep the Cooking Rack Clean:
Not only will a build-up of old food and cooking juices give grilled food an off taste, but delicate foods such as fish will stick to a dirty grill. A wire grill brush (see page 25) is invaluable for cleaning the cooking rack quickly and efficiently; use one after each grill session. If you've forgotten, use the grill brush before you grill next time, especially when you will be grilling fish.

2. Use Hardwood Charcoal: Natural charcoal made from mesquite or other kinds of hardwood is far superior to manufactured briquettes. Briquettes are made with fillers and are chemically treated, and they inevitably add an off taste to grilled food; hardwood charcoal imparts to food the slight perfume of the wood from which it was made. Briquettes burn at a lower heat than does natural charcoal, yet they also burn faster because of their fillers. Despite its higher initial cost, hardwood charcoal is thus more economical.

Mesquite is the best choice for hardwood charcoal, both because of its distinctive fragrance and because it burns hotter than other hardwoods, allowing you to sear foods more efficiently. Mesquite chunks may need to be broken up with a hammer or an axe, and they tend to shoot off an alarming number of sparks when first lit—you will need to make sure your grill isn't near anything flammable, including you and your clothes. If you don't have a local source for mesquite, look in our mail-order section on page 68, order it in quantity, and keep it in a large waterproof plastic garbage can near your grill.

3. Use a Charcoal Chimney: The cheapest and most reliable fire starter is a charcoal chimney. We strongly advise against the use of charcoal lighter, which adds its petroleum taste to food and its chemical wastes to the atmosphere.

4. Know When to Use a Direct or an Indirect Fire: Food to be cooked over a *direct fire* is placed on the cooking rack directly above the lighted coals. Foods that cook very quickly, such as ground meats and thinly sliced pieces of meat or vegetables, are cooked over a direct fire in an open grill. Foods that take a little longer to cook, such as thick steaks or chops or pieces of chicken, are usually seared on all sides over a direct fire, after which the grill is covered so that the food cooks more evenly.

An **indirect fire** is used for larger pieces of foods such as roasts and whole fish. The lighted coals are formed into a circle or two banks, and a metal drip pan is placed in the center. We like to use two banks of coals propped up with metal charcoal rails, because more coals can be stacked up and the fire is in less danger of dying. The indirect heat cooks more slowly and evenly, and the drip pan catches the fat and drippings from the grilling food. If the food being grilled isn't too fatty, you may use the drip pan to cook foods such as potatoes and other root vegetables. Or, you may add 1 or 2 inches of water or flavoring liquids to the drip pan to mingle with the drippings (and help keep the grilling food moist); degreased and reduced if necessary, this liquid makes an excellent sauce.

5. Use the Right Amount of Coals: Make sure that the spread-out charcoal covers an area slightly larger in diameter than the food itself. For an indirect fire, use about twice as many coals; they will be pushed into banks or a circle and will need to burn for a longer time.

6. Learn to Judge the Heat of the Fire: A fire is *hot* when the coals are red but covered with a layer of white ash; at this heat you will be able to hold your hand 6 inches from the cooking rack for 3 to 4 seconds. This is the heat used for most foods to be cooked directly over the coals. A fire is *medium hot* when you can

barely see the red coals glowing through the ashes and you can hold your hand 6 inches from the cooking rack for 5 to 7 seconds. This is the stage used for indirect fires and covered grilling. A fire is *low* when the coals are completely gray. The fire eventually will slow to this stage when the grill is covered.

7. Learn to Use Smoking Woods: To add the flavor of aromatic wood smoke to your food, soak wood chips or vine cuttings in water to cover for 30 minutes to 1 hour. Drain them, then sprinkle them evenly over the coals. Cover the grill, partially close the vents, and cook the food until done.

8. Learn to Regulate the Fire: *To make a fire burn hotter:* (1) Knock accumulated ashes off the coals by shaking the grill or tapping the coals with a metal tool such as a pair of tongs; or (2) push the coals closer together; or (3) completely open the top and bottom grill vents (on the lid and on the bottom of the grill). If the coals are used up, you will have to rebuild the fire by adding new coals (see No. 9, below). *To make a fire burn more slowly:* (1) Put the

lid on the grill; or (2) partially close the grill vents; or (3) push the coals farther apart. To put out flare-ups, cover the grill. If this doesn't work, as a last resort, spray the fire with water (see page 25).

9. Learn How to Rebuild the Fire: If you haven't used enough coals to start with, or if you've been cooking an hour or longer, you will need to rebuild the fire. The easiest way to do this is to light a charcoal chimney–full of coals about 10 minutes before you want to use them to rebuild your fire (this must be done on a fireproof surface, such as the fuel grate of a small portable grill). Or, you may add unlighted coals to the coals in the grill, but in this case you will have to wait 10 to 20 minutes until they are ready to cook over.

10. Learn to Tell When Food Is Cooked: An instant-read thermometer is a great help in judging doneness, but it works only in pieces of food that are at least 2 inches thick. Pieces of steak, chicken breasts, fish, and vegetables may have to be cut into to see whether they are sufficiently cooked. Large pieces of food

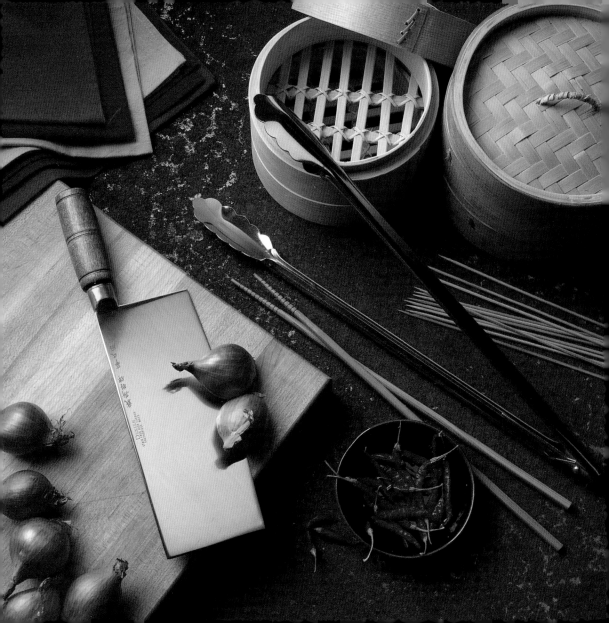

such as roasts and whole birds will begin to shrink slightly when they are done; when a piece of poultry is pierced with a knife, the juices should run clear.

GRILL TOOLS

This list of basic grilling tools will help you grill happily and well.

Charcoal chimney: Use this device instead of charcoal lighter.

Instant-read thermometer: A few minutes before you think meat or chicken might be done, insert this kind of thermometer to check the internal temperature.

Spray bottle: Keep a bottle of water with a spray attachment by the grill at all times. You can dampen most flares by covering the grill, but you should have water ready when that doesn't work.

Long-handled tongs: Save yourself trouble and pain by using a pair of metal tongs with spoon-shaped ends. Available in restaurant supply stores, these inexpensive tongs can be used to stir and move coals, to scoop basting liquid, and to turn almost anything on the grill. Store the tongs by hanging them over the handle of the grill.

Timer: Always use a timer when grilling; it's easy to become distracted, especially when you are cooking for a group. Look for the kind that clips to your apron.

Wire grill brush: This metal-bristled brush is essential for keeping the cooking rack clean. Use it after each grill session.

Other good grill tools include *grill mitts,* a *long-handled basting brush,* a *long-handled bent-blade spatula, charcoal rails* (to hold up banks of coals for an indirect fire), and *grill baskets* or *grilling grids* (small-meshed or perforated metal containers for small pieces of food, such as sliced vegetables or fish fillets, that otherwise would fall through the cooking rack).

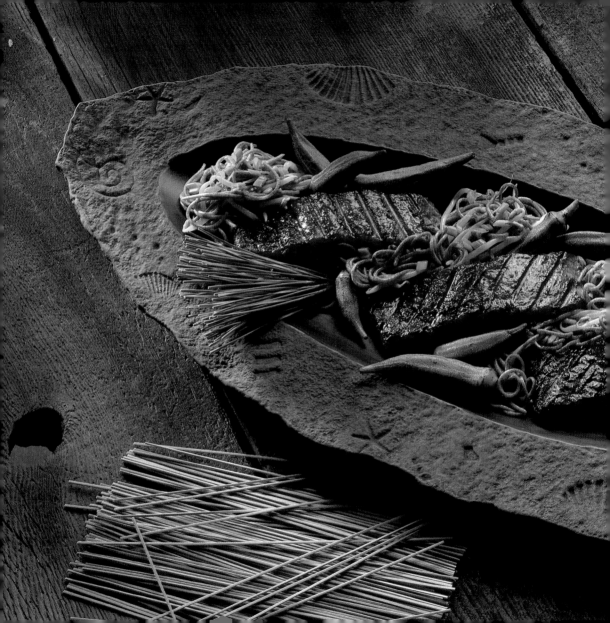

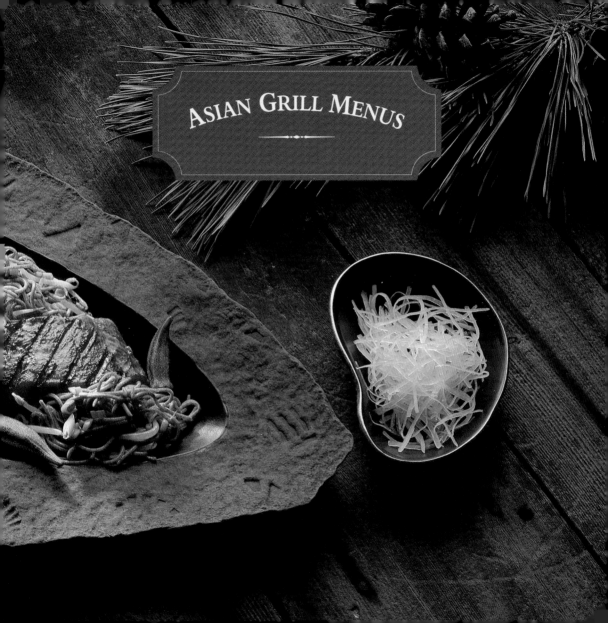

ASIAN GRILL MENUS

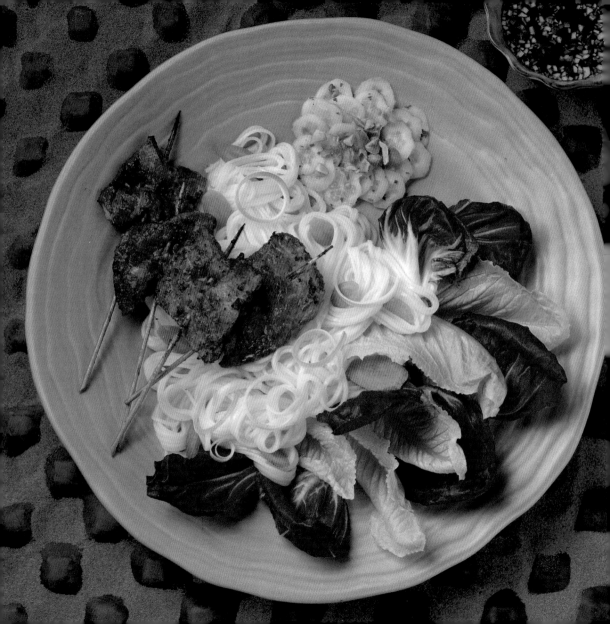

Vietnamese Pork Kabobs with Dipping Sauce

<div align="center">

Cold Rice Stick Noodles • Cucumber Salad

</div>

Serves 4

Pork kabobs are found on virtually every Vietnamese menu, either as a sataylike appetizer or as a main course. For this meal, the thin slices of grilled marinated pork are served over cold noodles on a bed of lettuce leaves, a typically Vietnamese mix of textures, temperatures, and tastes that is perfect on a hot summer's night. (Although it is far from traditional, we like to mix radicchio leaves with butter lettuce for an added contrast in texture, color, and taste.)

Vietnamese Pork Kabobs with Dipping Sauce

1 pound boneless pork butt, partially frozen
4 shallots, minced
2 garlic cloves, minced
2 teaspoons sugar
2 tablespoons fish sauce
¼ teaspoon freshly ground white pepper
1 tablespoon peanut oil

Nuoc Cham Dipping Sauce

4 garlic cloves, minced
1 tablespoon minced fresh hot red chili, or to taste
2½ tablespoons sugar
Juice of 1 lime
½ cup fish sauce
½ cup water, or to taste
2 tablespoons minced fresh cilantro

10 to 12 large butter lettuce leaves, or a mixture of butter lettuce and radicchio leaves
Cold Rice Stick Noodles (recipe follows)
2 carrots, peeled and cut into thin diagonal slices, for garnish
4 green onions, cut lengthwise into very thin slices, for garnish
Fresh cilantro sprigs for garnish

Cut the pork against the grain into slices ⅛ inch thick, then cut it again into pieces about 2 inches square. Thread the slices on bamboo skewers; place the skewers in a nonaluminum container. In a mortar or small bowl, combine the shallots, garlic, and sugar and grind to a coarse paste with a pestle or the back of a spoon. Add the fish sauce, pepper, and oil. Pour this mixture over the pork, turning the kabobs to coat both sides. Let sit at room temperature while you prepare the fire and the dipping sauce; turn the skewers once or twice during this time.

Light a charcoal fire in a grill. While the coals are heating, make the dipping sauce: Combine all of the ingredients in a small bowl and let sit at room temperature. When the coals are hot, line each of 4 plates with 2 or 3 lettuce leaves and mound the rice stick noodles on the leaves. Cook the kabobs for about 2 minutes on each side. Transfer from the grill to a platter. Place several skewers of pork on top of each serving of noodles and garnish the plate with the carrots, green onions, and cilantro sprigs. Accompany each plate with a small dish of dipping sauce.

Cucumber Salad

1 unpeeled English cucumber, or 2 regular cucumbers, peeled
½ cup water
¼ cup rice wine vinegar
2 teaspoons sugar
Salt to taste
6 tablespoons unsalted peanuts
¼ cup minced fresh cilantro

Cut the cucumber(s) into paper-thin slices and place in a medium nonaluminum bowl. In a small bowl, combine the water, vinegar, sugar, and salt, and pour over the cucumbers. Let sit at room temperature for 45 minutes to 1 hour.

Meanwhile, toast the peanuts: Heat a dry, heavy skillet over medium-high heat, add the peanuts and stir them constantly for 3 or 4 minutes, or until the nuts are fragrant and beginning to brown. Remove from heat and keep stirring for 2 or 3 minutes, then wrap the peanuts in a clean kitchen towel and let them cool for 10 or 15 minutes. When the nuts are slightly cooled, rub them in the towel to remove their skins. Pour the nuts into a colander and shake it to discard the skins. Chop the nuts coarsely and set them aside.

Drain the marinated cucumbers and toss them with the cilantro. Divide them among 4 salad bowls and sprinkle chopped peanuts over each.

Cold Rice Stick Noodles

Bring a large pot of salted water to a boil, add 10 ounces rice stick noodles, stir with a chopstick, and cook for 5 or 6 minutes, or until tender. Drain the noodles and place them in a covered bowl at room temperature until ready to use.

CHICKEN, ASPARAGUS, AND GREEN ONION YAKITORI

Steamed Short-Grain Rice • Cold Sesame Spinach

Serves 4

This Japanese grill menu combines chicken, asparagus, and green onions. Steamed short-grain rice and a cold marinated spinach dish complete the menu. Serve with chilled Japanese beer.

Chicken, Asparagus, and Green Onion Yakitori

2 chicken breast halves, skinned, boned, and cut into 1-inch cubes
2 chicken thighs, skinned, boned, and cut into 1-inch cubes
1 bunch green onions, cut into 1½-inch lengths (including some of the green part)
1 pound asparagus, cut into 1½-inch lengths

YAKITORI SAUCE
½ cup Japanese soy sauce
3 tablespoons sugar
1 tablespoon sake
2 tablespoons mirin or dry sherry

Light a charcoal fire in a grill. While the coals are heating, prepare the yakitori: Divide the cubes of chicken into 2 equal piles. Thread half of the cubes on bamboo skewers, alternating a piece of chicken, then a piece of green onion skewered crosswise. Thread the remaining cubes on bamboo skewers, alternating each piece of chicken with a piece of asparagus skewered crosswise. Place the skewers in a non-aluminum container.

To make the yakitori sauce: In a small saucepan, combine all the sauce ingredients and boil over medium-high heat for 5 to 6 minutes, or until the sugar is dissolved and the liquid is thickened. Brush this sauce evenly on all sides of the skewered chicken and vegetables and let

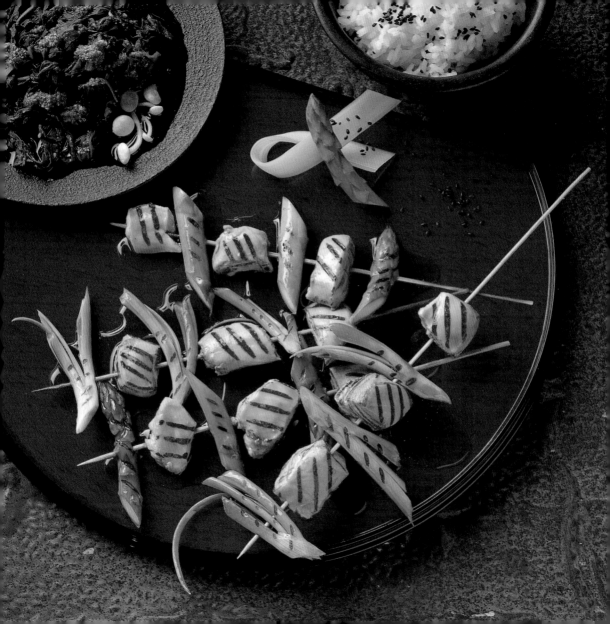

them sit at room temperature until the fire is ready.

When the fire is hot, grill the skewers for 3 to 4 minutes on each side, basting with the remaining sauce before and after turning, or until the chicken is glazed on the outside and opaque throughout. Serve the skewers over steamed rice.

Steamed Short-Grain Rice

1⅓ cups short-grain rice
1⅓ cups water

Immerse the rice in a pan of cold water, stir to rinse, and drain. Repeat several times until the water in the pan is clear. Let the rice sit in the last pan of water for 30 to 40 minutes, or until the rice is opaque; drain.

In a large saucepan over high heat, bring the water to a boil and stir in the rice. Cover and cook until steam comes out from under the lid, then reduce the heat to medium and cook for 5 minutes. Turn off the heat and let sit on the stove for 15 to 20 minutes, or until the water is absorbed and the rice is tender.

Cold Sesame Spinach

2½ pounds spinach, stemmed and
washed
½ cup sesame seeds
2 teaspoons sugar
2 tablespoons Japanese soy sauce
¼ cup dashi or canned chicken broth
2 teaspoons rice wine vinegar

Place the wet spinach in a large pot, cover, and cook over medium-high heat for 3 to 4 minutes, or until wilted. Place the spinach in a colander, rinse under cold water, and press with the back of a wooden spoon to remove excess water; set aside.

Heat a dry, heavy skillet over medium-high heat and add the sesame seeds; stir them constantly for 3 to 4 minutes, or until they begin to toast. Remove the pan from heat and continue to stir the sesame seeds for 2 or 3 minutes, or until they stop cooking. Pour them into a mortar or small bowl. With a pestle or the bottom of a small bottle, grind the seeds to a paste. Grind or stir in the remaining ingredients. Place the drained spinach in a bowl and stir in the sesame paste. Serve at room temperature or chilled.

Thai Dancing Prawns with Cilantro Sauce

Sticky Rice • Grilled Squid Salad

Serves 4

A delectable dish of stuffed prawns with a brilliant green sauce, Thai dancing prawns are usually served with their skewers inserted into a piece of fruit, so that the tails of the prawns are in the air as if they were dancing. Here they are accompanied with Thai sticky rice and a salad of grilled squid over shredded cabbage. Serve with cold Thai beer.

Thai Dancing Prawns with Cilantro Sauce

16 jumbo prawns
4 ounces ground pork
4 ounces fresh or thawed frozen crab
2 garlic cloves, minced
2 teaspoons fish sauce
1 teaspoon sugar
Freshly ground black pepper to taste
Peanut oil for coating

Cilantro Sauce

1 cup fresh cilantro leaves
6 tablespoons fresh lime juice
2 tablespoons fish sauce
1½ tablespoons honey
1 teaspoon minced hot green chili, or to taste

2 oranges, halved crosswise
Fresh cilantro sprigs for garnish

Light a charcoal fire in a grill. While the coals are heating, peel the prawns, leaving the tails intact. With a small sharp knife, make an incision in the outside curve of each prawn from the head end to the tail, but do not cut all the way through the flesh. Devein the prawns. In a blender or a mortar, grind the pork, crab, garlic, fish sauce, sugar, and pepper to a paste. Use this mixture to fill the prawns. Coat the prawns with the peanut oil. Insert a small

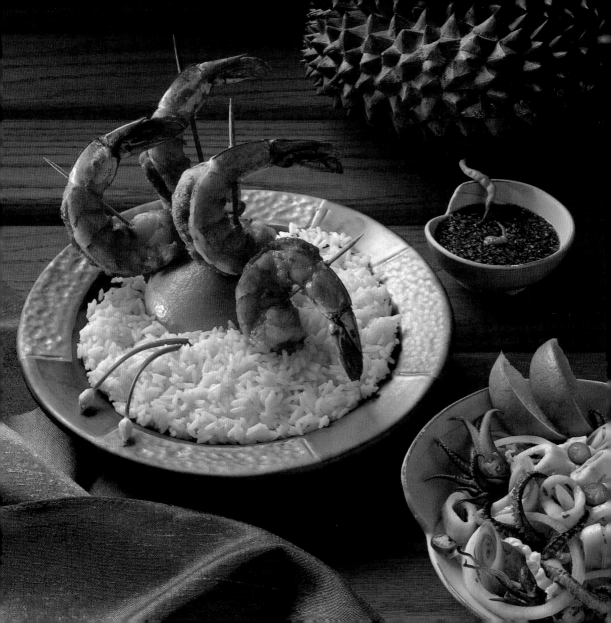

bamboo skewer vertically through each prawn.

Just before grilling the prawns, make the cilantro sauce (if you make it too far ahead, the bright green of the sauce will dull): In a blender, puree all the ingredients to a very smooth sauce. Cover and chill.

On each of 4 plates, place the 4 orange halves flesh-side down. When the coals are hot, grill the stuffed shrimp for 3 to 4 minutes on each side, or until they are evenly pink and opaque. Transfer from the grill to a platter. Insert 4 skewers of shrimp into each orange half and strew the plates with cilantro sprigs. Divide the cilantro sauce among 4 small dipping dishes and place one on each plate.

Sticky Rice

1½ cups sticky (glutinous) rice
4 large romaine lettuce leaves

Soak the rice in water to cover for 3 hours or overnight (the more the rice soaks, the shorter the cooking time). Drain the rice and place it on a rack in a steamer over boiling water. Steam uncovered for 30 to 40 minutes, or until the rice is tender and sticky (you will need to keep adding water to the steamer). Empty the rice onto an oiled baking sheet and, with the back of a wet metal spoon, spread it out to cool. When the rice has cooled to the touch, divide it into 4 large balls. Place each lettuce leaf on a salad plate and top with a rice ball; serve warm. To eat, pinch off a bite-sized piece of rice, roll it into a ball, and eat it plain or dip it into the cilantro sauce.

Grilled Squid Salad

8 small squid
Peanut oil for coating
2 cups shredded Chinese or napa
** cabbage**
½ sweet white onion, cut into rings
2 teaspoons minced hot green chili, or
** to taste**
1 stalk lemongrass, shredded, or
** 1 tablespoon shredded fresh ginger**
2 tablespoons fish sauce
2 teaspoons sugar
1 tablespoon fresh lime juice
2 tablespoons chopped fresh cilantro
Lime wedges for garnish

Buy squid that have already been cleaned, or clean them yourself as follows: Cut off the tentacles just above the head of each squid; cut off and discard the head. Squeeze out the hard round bone at the end of the tentacles. Press along the length of the body to squeeze out the intestines, then pull out the long, narrow bone that protrudes from the body. Rinse the tentacles and the inside and outside of the bodies with cold running water. Dry the squid parts well on paper towels.

Place the squid in a shallow pan and coat them evenly with the peanut oil. In a medium bowl, combine the cabbage with all of the remaining ingredients except the lime wedges; cover and chill for not more than 1 hour.

Divide the cabbage mixture among 4 salad plates. Using an oiled grill basket or grilling grid, cook the squid over hot coals for 5 to 7 minutes on each side, or until opaque and lightly browned. Transfer the squid from the grill to a cutting board and cut the bodies into ½-inch rings. Divide the squid among the salad plates, placing them on top of the cabbage. Garnish with lime wedges and serve.

INDONESIAN BEEF SATE WITH PEANUT SAUCE

Gado-Gado • Mango and Grilled Bananas

Serves 4

Skewers of thinly sliced meat served with peanut sauce is a famous Indonesian dish, while gado–gado is an Indonesian salad made from any number of steamed and/or raw vegetables and also served with a peanut sauce. For this menu, skewers of beef are served on a bed of raw vegetables, and the peanut sauce is used to flavor both meat and salad. The sliced mangos and grilled bananas may be served as a side dish or a dessert. Accompany this meal with steamed long-grain rice (see method for jasmine rice, page 63) and cold Asian beer.

Indonesian Beef Sate with Peanut Sauce

1½ pounds top round, cut against the grain into ½-inch-thick slices

MARINADE

¼ cup light soy sauce
½ teaspoon ground cumin
2 garlic cloves, minced
2 tablespoons peanut oil
½ teaspoon dried red pepper flakes
Dash ground coriander
1 teaspoon packed brown sugar

PEANUT SAUCE

2 garlic cloves, minced
1 tablespoon peanut oil
¼ cup minced onion
½ teaspoon shrimp sauce
¼ cup water
½ cup smooth peanut butter
¼ teaspoon salt
½ cup unsweetened coconut milk
½ teaspoon dried red pepper flakes, or to taste

Gado-Gado (recipe follows)

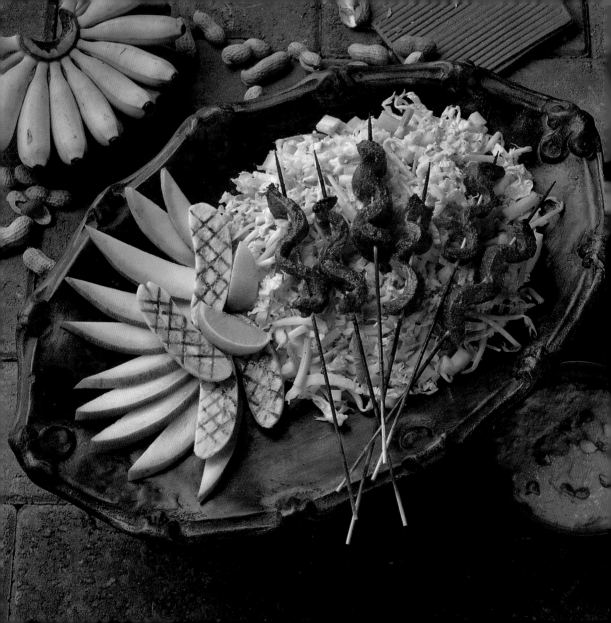

Light a charcoal fire in a grill. While the coals are heating, marinate the beef: Thread the beef strips on bamboo skewers and place them in a shallow nonaluminum container. In a small bowl, combine all the marinade ingredients and pour over the skewers. Let sit at room temperature until the coals are ready, turning the skewers once during this time period.

Meanwhile, make the peanut sauce: In a medium bowl, combine all the ingredients and blend thoroughly. When the coals are hot, grill the skewers for 2 minutes on each side. Divide the gado-gado among 4 serving plates and place the skewers on top of the salad; pour some peanut sauce over the vegetables and serve the rest alongside.

Mango and Grilled Bananas

1 mango
4 small bananas
Peanut oil for coating
4 teaspoons brown sugar
3 limes, each cut into quarters

Peel the mango, then cut wide lengthwise slices as close to the pit as possible. Cut these slices lengthwise into thin slices; set aside. Peel the bananas, halve them lengthwise, and coat them evenly with the oil. Grill the bananas over hot coals for 2 or 3 minutes on each side, or until lightly browned. Place 2 banana halves on each of 4 salad plates and sprinkle 1 teaspoon brown sugar over each pair. Divide the mango slices among the salad plates, placing them alongside the bananas. Squeeze 2 lime quarters over each serving of bananas and mangos, and garnish the plates with the remaining lime wedges. Serve at once.

Gado-Gado

3 cups shredded Chinese or napa cabbage
1½ cups fresh bean sprouts
½ cup shredded carrot
½ cup chopped cucumber
4 green onions, slivered and cut into 1-inch lengths
8 fresh cilantro sprigs with stems
Peanut Sauce (recipe on page 39)

In a large bowl, toss all the ingredients together. Serve as a bed for sate and accompany with peanut sauce.

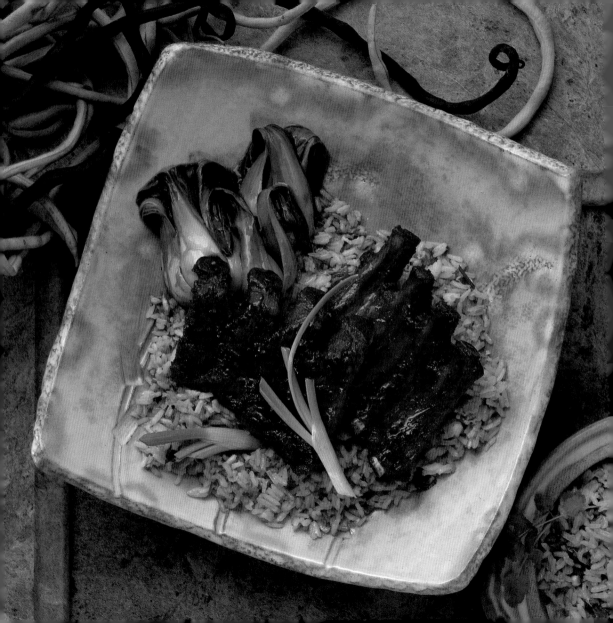

CHINESE BARBECUED SPARERIBS

Baby Bok Choy with Oyster Sauce • Stir-fried Rice with Green Onions and Cilantro

Serves 4

A deeply flavored, smoky sauce transforms spareribs in this favorite Chinese dish. We've paired the spareribs with a spicy stir-fried rice and a quickly made side dish of parboiled baby bok choy tossed with oyster sauce. Serve with a chilled Chinese beer or a spicy white wine such as Gewürztraminer.

Chinese Barbecued Spareribs

One 3½- to 4-pound slab pork
 spareribs
¼ cup peanut oil
2 tablespoons black bean paste
2 tablespoons hoisin sauce
6 garlic cloves, minced
¼ cup Chinese rice wine or dry sherry
½ teaspoon chili oil
2 tablespoons minced fresh ginger
2 tablespoons honey
1 tablespoon dark soy sauce

1 tablespoon Asian sesame oil
Freshly ground white pepper to taste
Fresh cilantro sprigs for garnish

Place the ribs in a large, shallow non-aluminum container. In a medium bowl, combine all the remaining ingredients except the cilantro sprigs and pour over the ribs, coating both sides. Let sit up to 2 hours at room temperature, turning the ribs once, or cover and marinate overnight in the refrigerator, turning the ribs several times.

 Light a charcoal fire in a grill. When the coals are hot, sear the ribs for 2 minutes on each side. Baste the ribs with the marinade, turn and baste them again, then cover the grill and cook them for 10 minutes on each side, basting before and after turning (for a total cooking time of 24 minutes). When done, the ribs will

be a rich mahogany color and the meat will show a trace of pink. Transfer the ribs from the grill to a platter, cover them loosely with aluminum foil, and let sit for 10 minutes. Uncover the ribs, garnish them with cilantro sprigs, and serve.

Stir-fried Rice with Green Onions and Cilantro

3 cups cooked long-grain rice
1 tablespoon light soy sauce
Freshly ground white pepper to taste
1½ tablespoons peanut oil
½ teaspoon chili oil
1 egg, beaten
½ cup chopped green onions
¼ cup minced fresh cilantro
¼ teaspoon Asian sesame oil

In a large bowl, combine the rice, soy sauce, and pepper. In a large wok or skillet, heat the peanut oil and chili oil until sizzling. Add the beaten egg and green onions and stir-fry for 30 seconds; add the rice and stir-fry for 3 to 4 minutes, or until blended and heated through. Stir in the cilantro and sesame oil; serve at once.

Baby Bok Choy with Oyster Sauce

Parboil 12 baby bok choy for about 3 minutes, or until the white base of one is crisp-tender when tested with a knife. Drain the bok choy well, place them in a large bowl, and toss them at once with ½ cup oyster sauce, or to taste. Serve hot.

Korean Barbecued Beef

Grilled Green Onions • Cold Noodle Salad

Serves 4

Koreans are known for their beef dishes, and the best-known of these is *bulgogi* ("fire meat"), or barbecued flank steak. Served with grilled green onions, cold noodle salad, one or more kinds of kimchi (chili-pickled vegetables), and chilled Asian beer, this is the perfect hot-day menu for those who love spicy food.

Korean Barbecued Beef

1½ pounds flank steak, partially frozen and sliced against the grain into ¼-inch-thick slices
1 tablespoon sesame seeds
3 garlic cloves, minced
¼ cup light soy sauce
1 teaspoon sugar
1 tablespoon Asian sesame oil
1 teaspoon dried red chili flakes
1 teaspoon grated fresh ginger

Place bamboo skewers in water to cover for 30 minutes. Thread the strips of meat on the skewers and place them in a shallow nonaluminum container. In a small, dry skillet over medium heat, stir the sesame seeds constantly until they are lightly toasted; let cool, then crush in a mortar with a pestle, or in a small bowl with the bottom of a small bottle. In another small bowl, combine the crushed seeds with all the remaining ingredients. Pour this mixture over the beef, coating it evenly; let sit at room temperature while you prepare the fire.

Light a charcoal fire in a grill. When the coals are hot, grill the skewers for 4 to 5 minutes on each side, or until done to your preference.

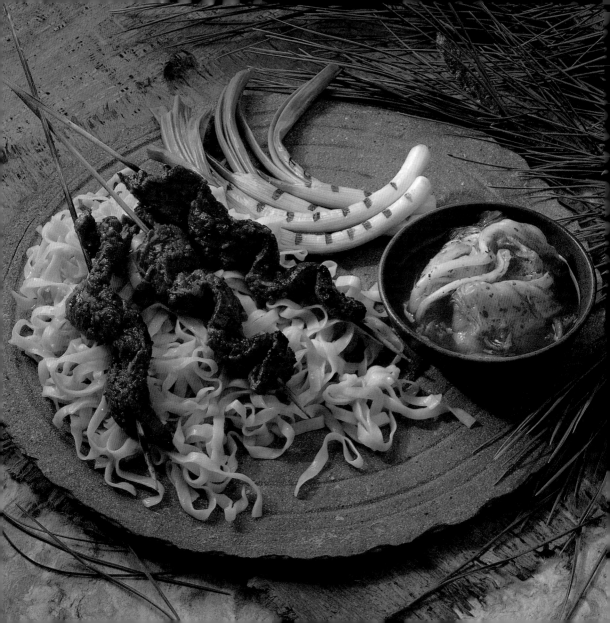

Cold Noodle Salad

**1 pound fresh or 8 ounces dried thin
 Chinese egg noodles**
1 tablespoon peanut oil
1 teaspoon Asian sesame oil
1 teaspoon chili oil
2 tablespoons light soy sauce
3 tablespoons rice wine vinegar
**½ cup skinned peanuts, chopped
 (optional)**
Fresh cilantro sprigs for garnish

In a large pot of boiling salted water, cook
the fresh noodles for 2 to 3 minutes and
the dried noodles for 6 to 8 minutes, or
until tender; drain. Rinse with cold water
and drain well. Place the noodles in a large
nonaluminium bowl. In a small bowl,
combine all the remaining ingredients
except the cilantro sprigs. Pour this
mixture over the noodles and toss to blend
well. Cover and refrigerate for 2 to 4
hours, tossing the noodles several times.
Serve cold, strewn with cilantro sprigs.

Grilled Green Onions

Trim 3 bunches of green onions so that
about 3 inches of the green part remains.
Coat the onions well with peanut oil.
Grill the onions over hot coals, turning
several times, until they are crisp-tender
and browned, about 6 to 8 minutes.

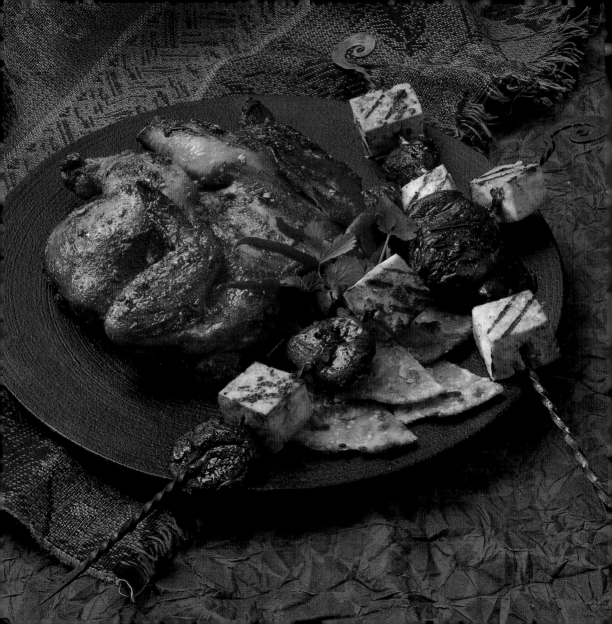

...RILLED GAME HENS

...rinated Tofu • Green Onion and Sesame Pancakes

3 garlic cloves, minced
3 tablespoons Chinese rice wine or
** dry sherry**
1 tablespoon minced fresh ginger
Fresh cilantro sprigs for garnish

Light a charcoal fire in a grill. While the coals are heating, prepare the birds: Cut each game hen, squab, or poussin in half along one side of the backbone, turn it over, and press down on the breast to make the bird lie flat. Cut out and discard the backbone. Cut a slit in the skin at the bottom end of each breast and tuck the end of the drumstick in the slit. (If using quail, leave them whole.) Place the birds in a nonaluminum container.

In a small bowl, combine all the remaining ingredients except the cilantro sprigs and pour the mixture over the birds. Let sit at room temperature until the coals are hot, turning the birds once during this time period.

When the coals are hot, sear the larger birds on each side for 2½ minutes; if using quail, sear them on all sides for a total of 5 minutes. Turn the larger birds bone-side down and baste the larger birds or the quail with the leftover marinade. Cover the grill, partially close the vents, and cook the larger birds for 10 minutes and the quail for 3 minutes. Baste, turn, baste again, cover the grill, and cook the larger birds for 8 to 10 minutes longer (for a total cooking time of 18 to 20 minutes) and the quail for 3 minutes longer (for a total cooking time of 11 minutes), or until the juices run clean when a thigh is pierced with a knife.

Transfer the birds from the grill to a large platter and cover them loosely with aluminum foil; let sit for 10 minutes. Uncover the birds and serve them garnished with cilantro sprigs.

Skewered Shiitake Mushrooms and Marinated Tofu

1 package firm tofu (about 14 ounces)

MARINADE

2 garlic cloves, minced
2 tablespoons peanut oil
4 tablespoons light soy sauce
2 tablespoons rice wine vinegar
2 tablespoons Chinese rice wine or dry sherry
¼ teaspoon freshly ground white pepper
¼ teaspoon dried red pepper flakes
1 teaspoon minced fresh ginger

16 large fresh shiitake mushrooms

Cut the tofu into 1-inch-thick slices. To drain the tofu: Place the slices on a baking sheet and place another baking sheet on top. Elevate one end of the pans several inches by placing a small measuring cup or small can under it; arrange the pans so that the other end drains into the sink. Place several tins of canned food on top of the top pan and let the tofu drain for about 30 minutes.

Cut the tofu into 2-inch lengths and place in a shallow nonaluminum container. In a small bowl, combine all the ingredients for the marinade and pour over the tofu. Cover and refrigerate for several hours or preferably overnight.

When you are ready to grill, stem the shiitakes. On metal skewers, thread the

mushrooms alternately with pieces of tofu. Brush the mushrooms and tofu with the leftover marinade. Grill the skewers over hot coals, turning them and basting with the marinade several times, for a total of 6 to 8 minutes, or until they are well browned and the mushrooms are tender. Serve on or off the skewers.

Green Onion and Sesame Pancakes

2 cups unbleached all-purpose flour,
 plus more for kneading if necessary
1½ teaspoons salt
¾ cup boiling water
2 tablespoons sesame seeds
¼ cup minced green onions
2 tablespoons peanut oil, plus more
 for frying
1 tablespoon Asian sesame oil
2 teaspoons chili oil

In a large bowl, mix the flour and salt with a fork. Gradually stir the boiling water into the flour mixture to form a dough, then stir in the sesame seeds and green onions; let cool. On a lightly floured board, knead for 5 to 8 minutes, or until smooth and elastic, adding flour 1 teaspoonful at a time as necessary to keep the dough from sticking. Cover with a damp towel and let rest for 30 minutes.

Cut the dough into 8 pieces. Roll each piece into a circle about ¼ inch thick. In a small bowl, combine the peanut, sesame, and chili oils. Brush each round with the oil, then roll each up like a jelly roll. Form each rolled round into a coil, flatten, and roll into a ¼-inch-thick circle. Heat a medium, heavy skillet over medium-high heat and pour in 2 teaspoons peanut oil. Add 1 pancake to the skillet and cook it for about 3 minutes on each side, or until golden brown, shaking the pan as you cook and adding 1 teaspoonful of oil if necessary; stack on a plate in an oven on very low heat and repeat until all the pancakes are cooked. Cut the pancakes into wedges and serve at once.

CHINESE GRILLED WHOLE FISH WITH DIPPING SAUCE

Bean Thread Noodles • Chinese Broccoli with Black Bean Sauce

Serves 4

The traditional Chinese steamed whole fish may be even better when it's cooked in a covered grill—the flesh is moist and faintly perfumed with the scent of charcoal, ready to dip into a refreshing, spicy sauce. Our grilled fish is served on a bed of delicate bean thread, or cellophane, noodles and accompanied with Chinese broccoli tossed in a pungent black bean sauce. Serve a chilled Chinese beer or a spicy white wine such as Johannisberg Riesling.

Chinese Grilled Whole Fish with Dipping Sauce

DIPPING SAUCE
¾ cup light soy sauce
3 tablespoons rice wine vinegar
3 tablespoons chopped fresh ginger
3 green onions, chopped
1 tablespoon Asian sesame oil
Freshly ground white pepper to taste

One 2-pound whole rock cod
Peanut oil for coating
Salt to taste
2 green onions, cut into 2-inch lengths
4 or 5 thin slices fresh ginger
Bean Thread Noodles (recipe follows)
Fresh cilantro sprigs for garnish

Light a charcoal fire in a grill. While the coals are heating, make the dipping sauce: In a small nonaluminum bowl, combine all the ingredients for the sauce. Set aside at room temperature.

Rinse the fish and pat it dry with paper towels. Oil the fish inside and out, then sprinkle the inside of the fish with salt. Place the onions and ginger in the cavity of the fish. With a large knife, cut a diagonal slash about ½ inch deep every 1½ inches in the flesh of the fish. Let sit at room temperature until the coals are ready.

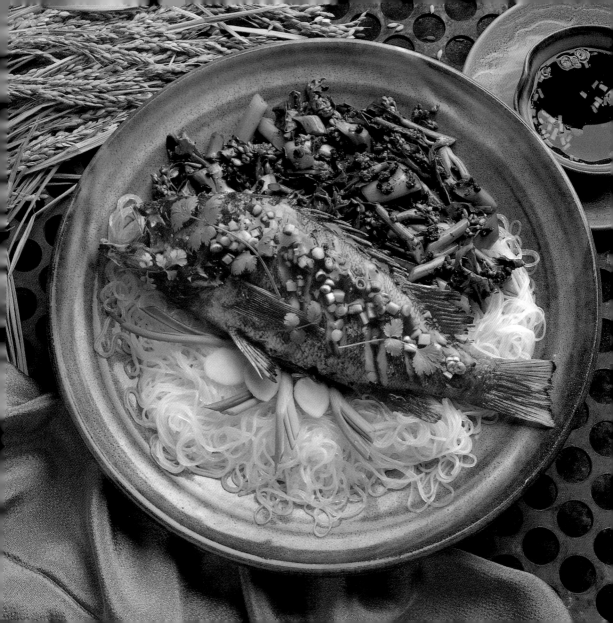

When the coals are medium hot, clean the cooking rack with a wire grill brush if necessary and oil the rack with a brush dipped in oil or a vegetable-oil spray (or use a heated and oiled fish grill basket or grilling grid if you have one). Place the fish over the coals, cover the grill, partially close the vents, and cook the fish for 4 minutes on each side, turning it very carefully with a wide-bladed spatula or 2 regular metal spatulas if you haven't used a basket or grilling grid. Place the fish on a platter and cover it loosely with aluminum foil; let sit for 10 minutes.

To serve, place the noodles on a heated platter, forming them into a bed or an oval ring. Place the fish on top or in the center of the noodles and pour about half of the dipping sauce over it. Strew the cilantro sprigs over the fish and serve a small bowl of the remaining dipping sauce with each plate.

Bean Thread Noodles

Soak 1 pound bean-thread (cellophane) noodles in warm water to cover for 10 minutes; use a chopstick to separate the noodles. Meanwhile, bring a large pot of salted water to a boil. Add the soaked noodles to the boiling water and let the water return to a boil. Drain the noodles and rinse them under cold water. Drain the noodles again and toss with 1 tablespoon peanut oil. Serve warm.

Chinese Broccoli with Black Bean Sauce

1½ pounds Chinese broccoli or regular broccoli
1 tablespoon peanut oil
2 tablespoons minced garlic
2 tablespoons fermented black beans, mashed to a paste
¼ cup canned low-salt chicken broth
Salt and sugar to taste

Cut the broccoli flowerets into 2-inch lengths; cut the tender part of the stems into ½-inch diagonal slices. Parboil the broccoli for 4 minutes; drain and set aside.

In a wok or a large skillet, heat the oil over medium-high heat until it sizzles. Add the garlic and stir-fry for 1 minute, then add the broccoli and stir-fry for 2 or 3 minutes. Add the remaining ingredients and stir until the broccoli is well coated. Serve at once.

CHICKEN TERIYAKI

Somen Noodles with Dipping Sauce • Skewered Okra

Serves 4

Teriyaki sauce is easy to make and is good on many kinds of meat and fish, but we prefer it on chicken. Skewers of grilled okra, and cool wheat noodles with a cool, savory dipping sauce, complete this menu, which is especially good on a hot day. Serve with chilled Japanese beer.

Chicken Teriyaki

3 to 4 pounds mixed chicken breast halves, thighs, and legs

TERIYAKI SAUCE
6 tablespoons sake
6 tablespoons mirin, or dry sherry with 1 teaspoon sugar added
½ cup tamari or dark soy sauce
1½ tablespoons sugar

Light a charcoal fire in a grill. While the coals are heating, prepare the chicken:

Place the chicken pieces in a shallow nonaluminum container. To make the teriyaki sauce: In a medium saucepan, combine all the sauce ingredients and cook over medium-high heat until the sugar has dissolved and the sauce has thickened, about 5 minutes. Brush the sauce evenly all over the chicken, reserving the extra sauce. Let the chicken sit at room temperature until the coals are ready.

When the coals are hot, sear the chicken for 2 minutes on each side, brushing with the sauce before and after turning. Brush the chicken again, turn and brush again, then cover the grill and cook the chicken for 6 to 8 minutes on one side. Brush, turn, brush again, and cook for 6 to 8 minutes on the second side (for a total cooking time of 16 to 18 minutes), or until the chicken is well browned on the outside and opaque throughout. Transfer the chicken from

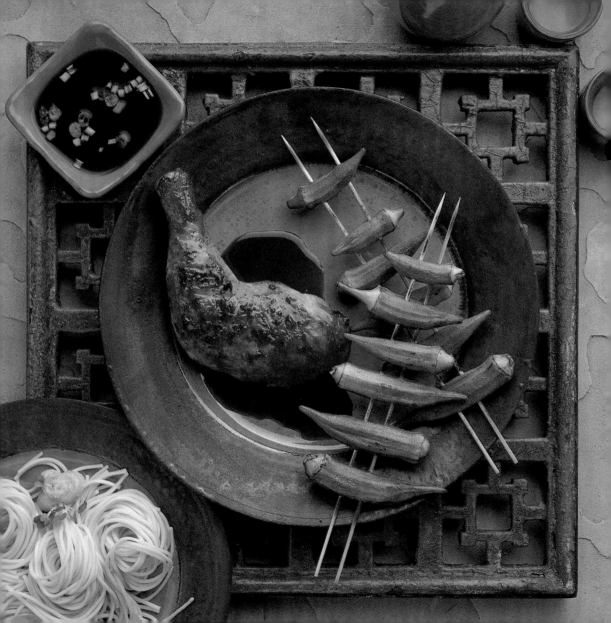

the grill to a platter and cover it loosely with aluminum foil. Let sit for 10 minutes, then uncover and serve.

Somen Noodles with Dipping Sauce

Four 3½-ounce bundles somen noodles
¼ cup noodle soup base
1 cup cold water
2 teaspoons prepared wasabi, or ½ teaspoon dried wasabi blended to a paste with 1½ teaspoons water
4 tablespoons minced green onions

Bring a large pot of salted water to a boil and add the noodles a few at a time; stir to separate the noodles. Bring the pot back to a boil and cook the noodles for 3 minutes; drain. Rinse the noodles in cold water and drain them again, then place them on a clean kitchen towel and pat them dry. Divide the noodles among 4 salad plates.

Dilute the soup base in the cold water and divide the broth among 4 small bowls. Place a bowl on each salad plate. In each of 4 small, flat condiment bowls, make separate mounds of ½ teaspoon wasabi and 1 tablespoon minced green onions.

To eat, each diner mixes the desired amount of wasabi and green onions into the soup base, then uses chopsticks to dip a bite-sized amount of noodles into the soup base.

Skewered Okra

24 large okra
Peanut oil for coating

Thread 6 okra crosswise on each of 4 sets of double skewers. (If using bamboo skewers, soak them in water to cover for 30 minutes before using.) With a brush, coat the okra evenly with peanut oil. Grill the okra over a hot fire for 2 to 4 minutes on each side, or until well browned and crisp-tender. Push off the skewers onto plates and serve at once.

GRILLED SALMON WITH MISO

Stir-fried Soba Noodles • Grilled Japanese Eggplant

Serves 4

Miso sauce gives a beautiful glaze and a complex sweet and spicy flavor to salmon fillets. Grilled Japanese eggplant and stir-fried soba noodles, with their pale pewter color and their subtle taste of buckwheat, round out the menu. Serve with Japanese beer or a fine California Chardonnay.

Grilled Salmon with Miso

4 green onions, trimmed 4 inches long

MISO SAUCE

½ cup red miso paste
1 egg yolk, beaten
6 tablespoons sake
3 tablespoons sugar
3 tablespoons dashi
1 tablespoon dark soy sauce

Four 8-ounce salmon fillets

Light a charcoal fire in a grill. Cut the green onions into thin lengthwise slivers and immerse them in a bowl of ice water; let sit until they are curled. Meanwhile, make the miso sauce: In a small bowl, combine all the ingredients and mix to a smooth sauce. Place in a double boiler and cook for 8 to 10 minutes, stirring occasionally, until the sauce thickens; set aside to cool. Spread the miso sauce on both sides of the salmon fillets and let them sit at room temperature while the coals are heating.

When the coals are hot, scrub the cooking rack with a grill brush if necessary and oil the cooking rack with a long-handled brush dipped in oil or a vegetable-oil spray. Place the salmon on the grill flesh-side down and grill for 5 to 6 minutes. Baste again with sauce, turn and baste again, and grill the fillets another

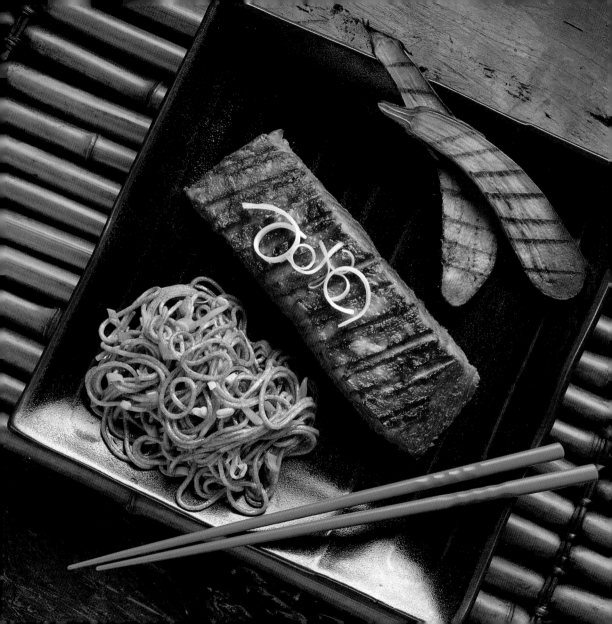

5 to 6 minutes, depending on how well done you like your salmon. Transfer from the grill to a heated plate or plates and serve garnished with the curled green onions.

Stir-fried Soba Noodles

8 ounces soba noodles
3 tablespoons Japanese soy sauce
2 teaspoons sugar
1 teaspoon minced fresh ginger
2 teaspoons sake
2 tablespoons peanut oil
1 cup fresh bean sprouts

Bring a large pot of salted water to a boil and add the soba noodles, stirring to separate them. When the water returns to a boil, cook the noodles for 6 to 8 minutes, or until tender; drain. Rinse the noodles in cold water, drain well, and set aside. In a small bowl, combine the soy sauce, sugar, ginger, and sake; set aside.

In a wok or a large skillet, heat the oil over medium-high heat until it sizzles. Toss in the drained noodles and stir-fry for 3 to 4 minutes. Pour in the soy sauce mixture and stir-fry for 2 or 3 minutes more. Add the bean sprouts and stir-fry for 1 minute. Serve warm.

Grilled Japanese Eggplant

Cut 4 Japanese eggplants into ¼-inch-thick lengthwise slices and coat them on both sides with peanut oil. Grill over hot coals for 2 to 3 minutes on each side, or until browned and tender. Serve warm.

THAI BARBECUED CHICKEN

Jasmine Rice Salad • Grilled Yams

Serves 4

In this Thai-inspired recipe, a simple marinade gives grilled chicken a bright, fresh taste; the dipping sauce combines many of the same flavors. Serve with grilled yam slices and a salad of mangos, shrimp, crisp vegetables, and fragrant jasmine rice. Add a cold Asian beer, and you will have a vibrantly flavored summer grill meal.

Thai Barbecued Chicken

4 boned unskinned chicken breast halves

MARINADE

2 tablespoons peanut oil
1 hot green chili, seeded and minced
3 tablespoons sugar
Juice of 2 limes
4 garlic cloves, minced
3 tablespoons fish sauce
1 tablespoon rice wine vinegar

DIPPING SAUCE

2 tablespoons minced fresh cilantro
1 tablespoon sugar
1 tablespoon fresh lime juice
¼ cup fish sauce
2 tablespoons water
Minced hot green chili to taste

Fresh cilantro sprigs for garnish

Light a charcoal fire in a grill. While the coals are heating, prepare the chicken: Place the chicken breasts in a shallow nonaluminum container. In a small bowl, combine all the ingredients for the marinade and pour over the chicken. Let sit at room temperature for 45 minutes, or until the coals are ready, turning the chicken once or twice.

When the coals are hot, cook the chicken for 4 minutes on each side, basting with the marinade before turning.

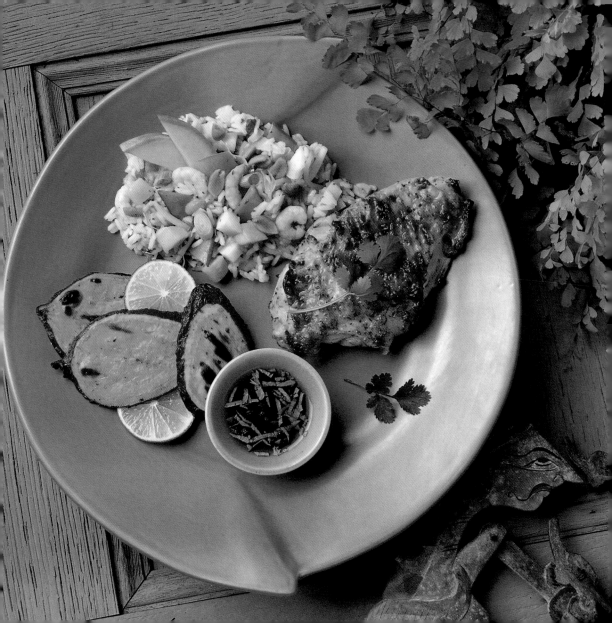

Baste and turn the chicken, baste again, cover the grill, partially close the vents, and cook for 4 minutes. Baste, turn, baste, cover the grill again, and cook another 4 minutes (for a total cooking time of 16 minutes), or until the flesh is opaque throughout.

Transfer the chicken from the grill to a plate, loosely cover with aluminum foil, and let sit for 10 minutes. Meanwhile, combine all the ingredients for the dipping sauce in a small bowl. Accompany each serving with a small bowl of dipping sauce and garnish the chicken with cilantro sprigs.

Jasmine Rice Salad

1½ cups jasmine rice
2½ cups water
¼ cup peanuts
1 cup blanched snow peas or sugar snap
 peas, cut in thirds on the diagonal
½ cup cooked baby shrimp
½ cup fresh bean sprouts
½ cup shredded peeled carrot
½ cup minced unpeeled English
 cucumber or peeled and seeded
 regular cucumber
1 cup finely diced mango

¼ cup shredded dried coconut
¼ cup minced green onion
2 tablespoons minced lemongrass
 (optional)

DRESSING

2 tablespoons minced fresh cilantro
2 tablespoons minced fresh mint
2 garlic cloves, minced
2 teaspoons minced fresh ginger
1 teaspoon minced hot red chili
1 tablespoon minced lime zest
3 tablespoons fish sauce
2 teaspoons sugar, or to taste
2 tablespoons rice wine vinegar

Fill a medium saucepan with water, add the rice, stir, and drain. Repeat twice. Place the rice and the 2½ cups water in the pan and bring to a boil. Stir the rice, cover the pan, lower the heat to a simmer, and cook for 15 minutes. Remove from heat and let stand for 10 minutes. Uncover and fluff the rice with a fork. Let cool to room temperature.

While the rice is cooling, toast the peanuts: In a small, heavy skillet over medium-high heat, stir the peanuts constantly for 3 to 5 minutes or until

fragrant and toasted. Place the peanuts in a clean kitchen towel and let cool for about 15 minutes. Rub the peanuts inside the towel to remove the skins. Empty the towel into a colander and shake it to discard the skins. Chop the peanuts coarsely.

Place the rice in a large bowl. Add the chopped nuts and all the remaining ingredients except the dressing, stirring gently to combine. In a small bowl, combine all the ingredients for the dressing and mix well to dissolve the sugar. Pour the dressing over the rice and stir gently to combine. Serve at room temperature.

Grilled Yams

**2 ruby yams, peeled and cut into
 ¼-inch-thick lengthwise slices
2 tablespoons peanut oil
1 tablespoon fresh lime juice
Salt and cayenne pepper to taste**

Place the yam slices in a large bowl. In a small bowl, combine the remaining ingredients and pour over the yams; toss to coat. Place the yams over hot coals, partially close the vents, cover the grill, and cook the yams for 5 to 6 minutes on each side, or until tender (for a total cooking time of 10 to 12 minutes).

VIETNAMESE BARBECUED BEEF WITH RICE PAPERS

Carrot and Radish Salad • Grilled Asparagus

Serves 4

A delightful mixture of fresh and spicy flavors, Vietnamese barbecued beef is marinated, grilled, and wrapped in tissue-thin rice paper pancakes with mint leaves and cilantro sprigs. It's accompanied with a dipping sauce, a crisp, refreshing salad of carrots and radishes, and quickly grilled asparagus. If you want another starch, add the rice stick noodles on page 31. Serve with chilled Asian beer.

Vietnamese Barbecued Beef with Rice Papers

1 pound top round, partially frozen and cut into ⅛-inch-thick slices

MARINADE

1 tablespoon sesame seeds
1 stalk fresh lemongrass, finely chopped, or 1 tablespoon dried lemongrass
2 teaspoons sugar

3 garlic cloves, minced
1 tablespoon fish sauce
1 teaspoon Asian sesame oil
¼ teaspoon freshly ground white pepper

DIPPING SAUCE

3 tablespoons peanuts
1 garlic clove, minced
2 tablespoons Vietnamese or Japanese soy sauce
1 tablespoon fish sauce
1 tablespoon rice wine vinegar
¼ cup water
1 tablespoon peanut butter
1 tablespoon sugar

1 package fresh or dried rice papers or 1 head butter lettuce, separated into leaves
Fresh mint leaves for garnish
Fresh cilantro sprigs for garnish

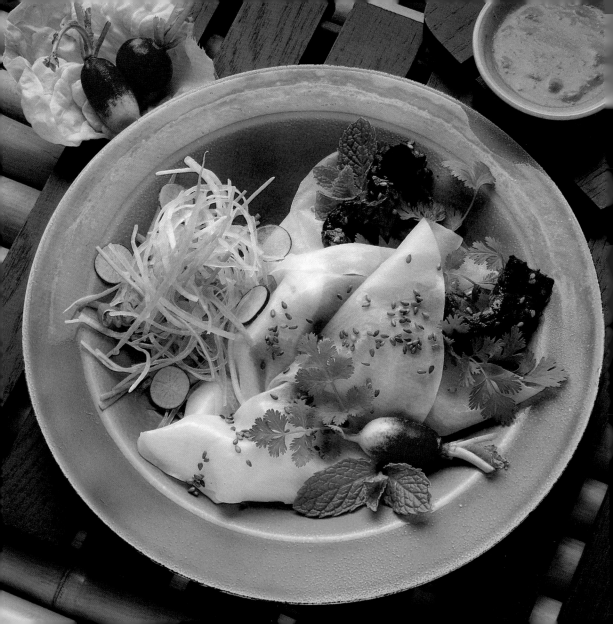

Light a charcoal fire in a grill. While the coals are heating, thread the beef slices on bamboo skewers and place them in a shallow nonaluminum container. In a small bowl, combine all of the marinade ingredients and pour the marinade over the skewers; let sit at room temperature while the coals are heating.

To make the dipping sauce: Toast and chop the peanuts as described in the method for Jasmine Rice Salad, page 63. In a small bowl, combine the peanuts and the remaining sauce ingredients; set aside. When the coals are hot, place the skewers on the grill and cook the beef for 2 to 3 minutes on each side. Transfer the skewers to a platter and let cool.

If you are using dried rice papers, brush each one on both sides with water and stack them on a plate, or arrange them individually on a damp towel and cover with another damp towel until they are softened. Divide the skewers among 4 serving plates. Give each person a stack of rice papers or lettuce leaves, a pile of mint sprigs and another pile of cilantro sprigs, and a bowl of dipping sauce. To eat, place a slice of beef, a sprig of mint, and 2 or 3 cilantro sprigs in a rice paper or a lettuce leaf, roll into a cylinder, and dip in sauce.

Carrot and Radish Salad

2 carrots, peeled and shredded
1 white radish, peeled and shredded
5 or 6 red radishes, sliced thin
2 tablespoons rice wine vinegar
½ cup water
2 teaspoons sugar
¼ cup chopped green onions

In a medium bowl, combine all the ingredients. Cover and refrigerate for 1 hour; drain and serve.

Grilled Asparagus

Snap off and discard the tough bottoms of 2 pounds of asparagus. Coat the asparagus with 3 tablespoons peanut oil and place them over hot coals perpendicular to the grill grids. Cook the asparagus for a total of 6 to 7 minutes, or until crisp-tender, turning them with tongs as necessary to brown them evenly. Transfer the asparagus to a warm plate, sprinkle with salt and freshly ground white pepper, and serve at once.

MAIL-ORDER SOURCES

GRILLS

Hasty Bake
7656 E. 46th Street
Tulsa, OK 74145
800-426-6836
918-665-8225
Charcoal ovens

Kamado
BSW, Inc.
4680 East Second Street
Benicia, CA 94510
707-745-8175;
fax 707-745-9708
Ceramic grill-ovens in
several sizes.

Weber
Weber-Stephen Products
Company
560 Hicks Road
Palatine, IL 60067-6971
847-705-8660 (in Illinois),
or 800-446-1071;
fax 847-705-7971
Charcoal kettle grills
in several sizes and styles.
web site
www.webberbbq.com

CHARCOAL AND SMOKING WOODS

Charcoal Companion
7955 Edgewater Drive
Oakland, CA 94621
510-632-2100 (in California),
or 800-521-0505;
fax 510-632-1986
A wide variety of smoking
woods.

Desert Mesquite of Arizona
3458 East Illini Street
Phoenix, AZ 85040
602-437-3135
Mesquite smoking wood.

Hasty Bake
7656 E. 46th Street
Tulsa, OK 74145
800-426-6836
918-665-8225
Oak and Hickory lump
charcoal

Humphrey Charcoal Corporation
P.O. Box 440
Brookville, PA 15825
814-849-2302

Hardwood charcoal;
wholesale and regional only.

Lazzari Fuel Company
P.O. Box 34051
San Francisco, CA 94134
415-467-2970 (in California),
or 800-242-7265;
fax 415-468-2298
Mesquite charcoal and
smoking woods.

Luhr Jensen & Sons, Inc.
P.O. Box 297
Hood River, OR 97031
541-386-3811 (in Oregon),
or 800-535-1711;
fax 541-386-4917
Smoking woods.
web site
www.luhr-jensen.com

GRILLING ACCESSORIES

Charcoal Companion
7955 Edgewater Drive
Oakland, CA 94621
510-632-2100 (in California),
or 800-521-0505;
fax 510-632-1986
A wide variety of grill
accessories

FOODS

Brae Beef
P.O. Box 1561
Greenwich, CT 06836-1561
203-869-0106;
fax 203-661-2689
Naturally raised beef.

D'Artagnan
280 Wilson Avenue
Newark, NJ 07105
800-327-8246;
fax 973-465-1870
Naturally raised chicken;
farm-raised game birds, game
meats, and lamb.
web site
www.dartagnan.com

Durham–Night Bird
358 Shaw Road, No. A
South San Francisco, CA
94080
415-737-5873;
fax 415-737-5880
Naturally raised chicken,
game birds, beef, and free-
range veal.

Pacific Seafoods
3380 Southeast Powell Blvd.
Portland, OR 97202
503-233-4891;
fax 503-234-9242
Northwest Pacific salmon
and other fresh fish and
shellfish in season.

Simply Shrimp
7794 NW 44th Street
Ft. Lauderdale, FL 33351
800-833-0888;
fax 954-741-6127
Gulf shrimp and a wide
variety of other fresh fish and
shellfish in season.

Summerfield Farms
10044 James Monroe
Highway
Culpepper, VA 22701
540-547-9600;
fax 540-547-9628
Naturally raised veal, lamb,
and poultry.

Walnut Acres
Penns Creek, PA 17862
800-433-3998,
fax: 717-837-1146
A wide variety of organic
foods, including naturally
raised chicken, meats, and
turkey; grains; dried fruits;
cheeses; fresh fruits and
vegetables. Catalogue;
24-hour mail order.
web site
www.walnutacres.com

Wolfe's Neck Farm
10 Burnett Road
Freeport, ME 04032
207-865-4469;
fax 207-865-6927
Naturally raised beef; regional
home delivery; retail store.

Index